*AIRBRUSH
ARTIST'S
LIBRARY*

STENCILS

AND

MASKS

JUDY MARTIN

AIRBRUSH
ARTIST'S
LIBRARY

STENCILS
AND
MASKS

JUDY MARTIN

NORTH LIGHT BOOKS

Cincinnati, Ohio

This book was designed and produced by
QUARTO PUBLISHING PLC
The Old Brewery, 6 Blundell Street
London N7 9BH

SERIES EDITOR JUDY MARTIN
PROJECT EDITOR MARIA PAL
EDITOR RICKI OSTROV
DESIGN GRAHAM DAVIS
PICTURE RESEARCHER JACK BUCHAN
ART DIRECTOR MOIRA CLINCH
EDITORIAL DIRECTOR CAROLYN KING

Typeset by Text Filmsetters, London
Manufactured in Hong Kong by Regent
Publishing Services Ltd
Printed by Leefung-Asco Printers Ltd, Hong Kong

A QUARTO BOOK

First Published in the USA by
North Light Books, an imprint of
F & W Publications, Inc
1507 Dana Avenue
Cincinnati, Ohio 45207

ISBN 0-89134-261-3

CONTENTS

THE ART OF MASKING 6

MASKING MATERIALS: LAYING MASKING FILM 8

TRANSFERRING A DRAWING TO THE SUPPORT 10

USING MASKING FILM: TWO-COLOR IMAGE 14

ERRORS AND PROBLEMS IN USING MASKING FILM 18

CUTTING MASKING FILM: ANGLES AND CURVES 20

MASKING SEQUENCES: OVERSPRAYING COLOR AND TONE 24

USING PLASTIC TEMPLATES: REGULAR SHAPES AND CURVES 30

CUT-CARDBOARD STENCILS: MOTIFS AND REPEAT PATTERNS 34

USING STENCILS: MULTIPLE IMAGES 36

LOOSE MASKING: CUT AND TORN CARDBOARD 38

MASKING FLUID: DETAIL AND TEXTURE 44

USING FABRICS TO CREATE SPRAYED TEXTURES 48

FOUND OBJECTS: THREE-DIMENSIONAL MASKING 50

PROJECT: COMBINED MASKING TECHNIQUES 54

GLOSSARY 62

INDEX 64

THE ART OF MASKING

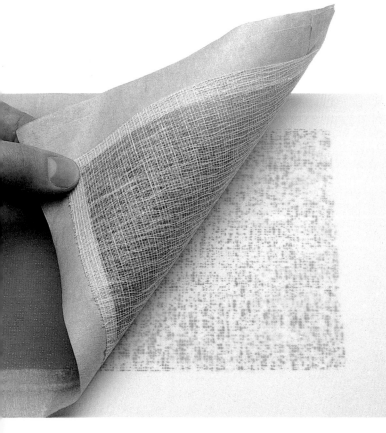

Masking is the concealed art of airbrushing, the important skill that turns a spray of color into a highly controlled design element. As soon as the basic manipulation of the tool is mastered, the airbrush artist needs to be able to apply the spraying technique to a specific task. But few airbrushed works are carried out by freehand spraying. It is through masking techniques that the artist provides the depth and definition of the image, and in doing so is required to combine the visual facility of a draftsman and painter with basic mechanical skills no less crucial to the success of the finished work.

A mask is, simply, anything that stands in the path of the airbrush spray and prevents the particles of color from falling on the support in a given area. The spray of color may fall through or around the mask. The masking material that gives the greatest control and precision is masking film, a product specially developed for airbrush art, but literally anything can be used as a mask, from tissue paper, to fabric, to three-dimensional objects.

The advantages of masking film, a self-adhesive plastic film that totally excludes the airbrush spray, are that it clings to the support tightly, can be cut accurately into intricate shapes and, because it is thin and cohesive, creates a hard, precise edge to the sprayed area. Being transparent, it also allows the artist to see the image beneath, whether this is line artwork or previously applied colors.

Because masking film can be used so precisely, planning the sequence in which the mask pieces are removed and different areas sprayed is of great importance to the final result. This is largely a matter of the style of the work and the experience of the artist: there are no hard and fast rules that guarantee success, but there are useful guidelines. It helps to spray first mid-toned areas that establish a key by which other colors can be judged. Some artists prefer to spray broad background areas first, others leave this part of the image until last. If using watercolor, or another transparent medium, the masking sequence can be planned to include overspraying, to darken tones or combine colors, as a positive element. Generally, various sections of the image should be worked to the same degree of finish before fine details are added — these should come last.

To establish a masking sequence, an accurate and detailed guideline needs to be drawn and careful draftsmanship is an essential part of the process. There are various ways of transferring a keyline to the support or to the masking film directly, and this too is a matter of individual preference based on such considerations as the surface quality of the support, the medium to be used and the character of the design.

Masking film is widely used because it allows the artist control over the definition of the image, but its properties are occasionally less advantageous than they first appear; for example, in a highly complex work taking several days to complete. It may be necessary to renew the masking film, for various reasons: it becomes covered with spray as the colors are applied and is no longer see-through; if left too long on the support, the adhesive may begin to affect the underlying surface. It can also happen that pieces of masking film removed from the support stretch during handling and cannot be accurately repositioned. Sometimes, it is simply the case that the effects that masking film produces are inappropriate to a particular element of an image.

Loose masks held on or above the support contribute a variety of edge qualities, a range of surface textures and, in the case of stencils and preformed templates, specific shapes that can be repeated with accuracy any number of times. This is an area well worth experiment, because although there are a few materials consistently used for particular masking effects — cotton for clouds, torn blotting paper for soft horizon lines, for example — there are all sorts of fabrics, sheet materials and everday objects, from leaves to paper clips, that can produce unexpectedly successful solutions to given problems.

This book examines in detail the complete range of masking techniques and the methods of putting them to use, including both materials purpose-made for designers and artists and items that may not normally be considered in this context, but which can become art materials in the hands of the inventive airbrusher. It is intended not only to demonstrate widely-used techniques and to present ways of handling common masking problems, but also to inspire an individual approach to this vital aspect of airbrush art.

MATERIALS FOR MASKING: LAYING MASKING FILM

Of the masking materials used in airbrushing, masking film is by far the most accurate and versatile. The colorless, transparent film has a coating of low-tack adhesive on one side, which is protected by a backing paper. Masking film adheres firmly to a smooth surface and can be applied to a clean support or laid over previously sprayed color when dry. The low-tack adhesive allows the film to be easily removed without damage to the underlying surface.

Masking film is available in sheets or rolls (see right). As the shape of the required mask is cut after the film has been laid on the support, an extremely sharp, lightweight blade is required for cutting. X-acto knives are available with different types of handles and blades (above right). The choice of a straight or rounded blade, a solid or narrow-necked handle depends both upon the artist's preference and the flexibility required by the work. Compass and swivel knives are also available for cutting curves.

General studio equipment should include rulers, erasers and masking tape. Acetate sheets are useful for loose masking (see page 38), and masking fluid (see page 44) for textural detail.

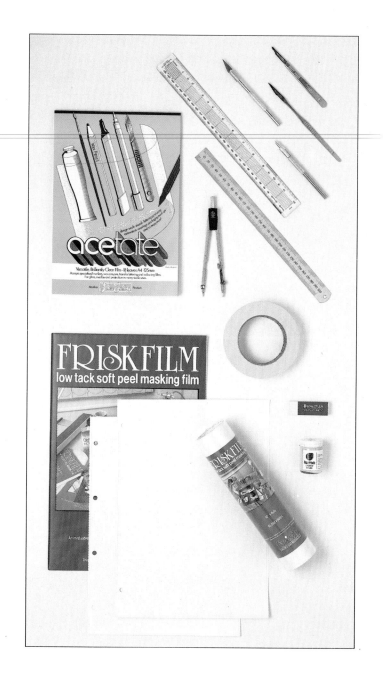

Common problems in laying masking film include poor adhesion due to dirt on the support surface, and bubbles appearing in the film where air pockets are trapped. The following method eliminates both of these problems and produces a smooth, well-adhered mask. Before laying the masking film, clean the support thoroughly with lighter fuel or other suitable solvent **1**; afterwards avoid making fingerprints on the surface. Cut the masking film to size and peel the backing from one corner. Smooth this down on the corner of the artboard **2**. Position the edge of a ruler on the film and take the backing paper in the other hand **3**. Gradually push the ruler edge flat across the film to smooth it down on the board, peeling away the backing film at the same time **4**.

1

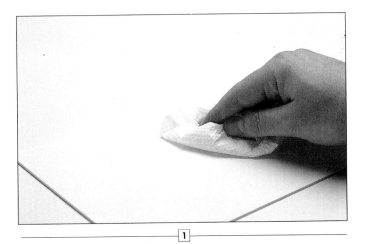

3

2

4

LAYING MASKING FILM

TRANSFERRING A DRAWING
TO THE SUPPORT

The first step in working with masking film is to establish an accurate line drawing as a guide to cutting the required pieces of the mask when the film is laid on the support. There are several ways of transferring an original drawing to the support or directly onto the masking film. One is the conventional method of tracing, which is quite laborious. Graphite paper saves time, and the drawing can be applied either to the support or to the upper surface of the masking film. Colored transfer papers are available which may be used in the same way.

A clean and economical method is to pick up the pencil line from a trace on the adhesive back of the masking film, which is then clearly visible on the support when the mask is laid but is not actually transferred to the board or paper surface. This is particularly useful to artists working with a transparent medium in which any marks on the support may show through the sprayed color. Although this is less crucial when opaque gouache is used, it is always important to keep the support as clean as possible: avoid using soft pencils which cause smudging and press firmly when tracing to create a clean line.

Make an accurate line drawing on tracing paper, either drawn directly or traced from an original. Turn the tracing paper over and redraw the lines on the back, following the shape precisely, using a fine pencil **1**. Tape the tracing right side up to the support and go over the drawing again with a sharp pencil to transfer the graphite lines beneath to the surface of the support **2**. Lift one corner of the tracing paper before removing the pieces of tape keeping it in place, to check that all the detail has been traced down on the support **3**.

**USING GRAPHITE PAPER
ON THE SUPPORT**

Draw up a complete image on tracing paper. Tape one edge of the tracing paper to the support; lift the opposite edge, and slide a piece of graphite paper black side down underneath the trace **1**. Work across the whole drawing with a sharp pencil, retracing every line **2**. Leaving some tape in place to hold the drawing in position, lift a corner of the graphite paper to check the quality of line on the support **3**. Remove the trace and graphite paper completely and erase any smudges of graphite, leaving the line drawing completely clean, before laying masking film **4**.

2

USING GRAPHITE PAPER
ON MASKING FILM

1

3

Clean the support with a solvent to remove any greasy marks or dust. Lay masking film over the whole of the support **1**. Make a tracing of the image to be transferred, outlining the outer edges of the work. Tape the trace to the masked support and insert a sheet of graphite paper. Retrace the entire image, including the frame **2**. Leaving one taped corner in place, lift the opposite corner of the trace and graphite paper to check the quality of the transferred line **3**. Remove both when the drawing is complete.

Make a clear line drawing on tracing paper, using a firm pencil line **1**. Cut a piece of masking film to the appropriate size and lay it on the tracing paper to adhere firmly and smoothly **2**. Retrace the outline of the image on the surface of the film, using a round-tipped stylus **3**. Peel back the masking film from one corner to check the adhesive underside of the film **4**. The graphite line should have transferred evenly from the trace to the adhesive back of the film. Lift the masking film from the trace and carefully apply it to a clean support **5**. By this method the film can be accurately cut without the need for linework on the surface of the support.

TRANSFERRING A TRACE TO THE ADHESIVE SIDE OF THE FILM

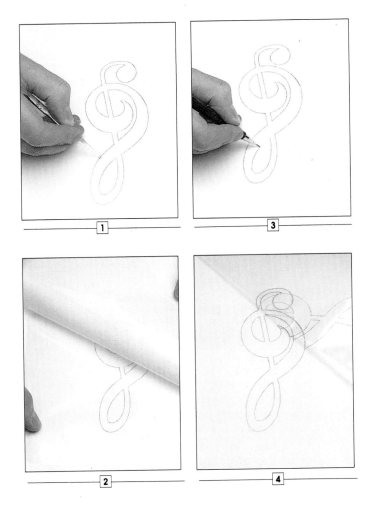

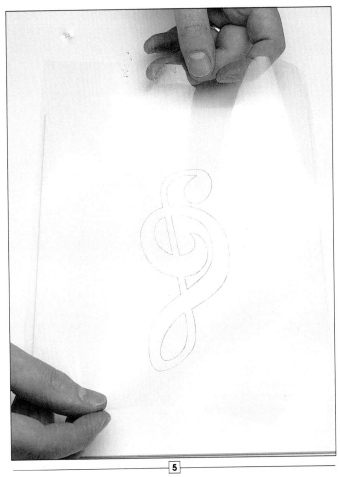

TRANSFERRING A DRAWING

USING MASKING FILM:
TWO-COLOR IMAGE

This exercise shows a simple masking sequence for spraying a drawing of a beach ball with two main colors and a shadow effect. A single sheet of masking film is laid over the whole surface. All the cutting of the mask takes place at the beginning of the sequence and the mask pieces are then lifted and replaced in order of the colors to be sprayed. The image has been devised with minimal detail to show the masking method stage by stage, but this is the basic technique by which all types of film-masked airbrush artwork are completed. A more complex image means there are more mask sections.

The pictures demonstrate the method of hinging the mask sections with adhesive tape to keep them in position to be easily replaced. It is important to keep the lifted piece of mask out of range of the airbrush spray, as it is adhesive-side up while not in use. If preferred, the mask section can be completely removed. It is essential that masks are replaced accurately after spraying. Imperfectly placed masks cause either an unsprayed white line between areas of the image or a line of the wrong color to appear at the edge of a shape.

Draw a circle on the artboard surface. Using a French curve, draw a wavy band across the center (as shown in the finished image on page 17) . Make sure that the surface of the board is clean and apply masking film to the whole area. Using a very sharp X-acto knife, cut all the lines of the drawing – the outline of the ball and both lines of the central band **1**. The cutting can be done freehand if you are confident of following the lines accurately, otherwise use a compass knife to cut the circle (see page 21) and a French curve to guide the X-acto knife when cutting the band.

Place hinges of adhesive tape across the edges of the upper and lower sections of the mask. With the point of the scalpel, lift the tip of the lower mask section **2** and lift it from the board. Take the mask between finger and thumb and peel it gently back from the surface **3**.Take it clear of the section to be sprayed and allow it to remain secured by the tape hinge. Repeat the process to lift and turn back the upper section of the mask, exposing the areas of the drawing to be sprayed green.

2

3

To save wasting masking film, when a large area of background is to be masked while spraying a relatively small area, use a piece of film to mask the immediate area around the section being sprayed and mask the rest with paper to protect the support from any overspray. When pieces of mask are removed during spraying, keep them on a piece of the backing paper to prevent the adhesive side from gathering dust.

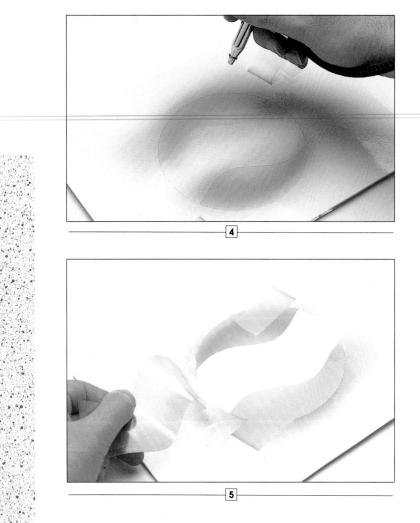

Spray the central section of the ball with yellow watercolor, matching the tonal distribution of the green sections to keep the shadow near the edge and the highlight toward the center **6**. You will be able to see the overall gradation of the green through the transparent masking film to check the tonal balance. When the yellow band is complete, allow the color to dry completely; then replace the central band of masking film **7**.

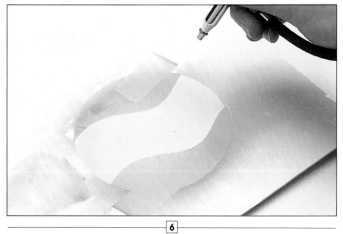

Charge the airbrush with green watercolour and spray the two exposed sections with a graded tone **4**, with the darkest areas inside the upper and lower curves of the circle and highlight areas on either side of the central band, to create the effect of a sphere. When the colour is dry, replace the sections of mask over the green areas, making sure they fit the shapes precisely. Hinge and peel back the central band of masking film **5**.

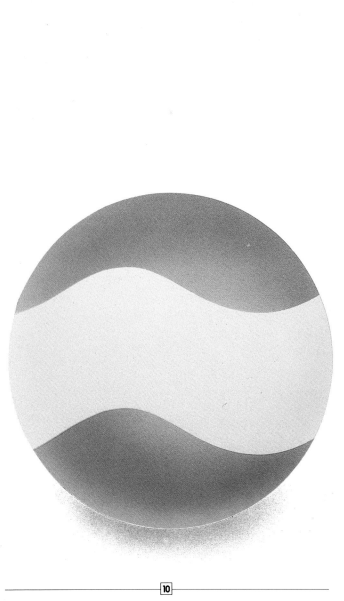

Remove the tape hinges from the edges of the cut mask. Leaving the masking over the ball undisturbed, remove the whole of the background masking **8**, pulling it back evenly starting from one edge. Charge the airbrush with Payne's gray and spray lightly around the base of the masked ball to indicate a cast shadow **9**. Pass the airbrush back and forth to build up the tone, but aim for a mid-toned rather than dark effect, graded outward.

The final image **10** shows how the masking has kept each color area distinct and clean, yet the overall surface effect is completely unified, with highlights and shadows corresponding between the green and yellow areas. The extremely simple masking sequence produces a sophisticated impression typical of airbrush work.

TWO-COLOR IMAGE

ERRORS AND PROBLEMS
IN USING MASKING FILM

Learning to use masking film efficiently is to some extent a matter of trial and error, but there are various common problems that can easily be avoided by following a few simple ground rules.

It takes practice to acquire expertise in cutting masking film, as this needs a light but firm touch, with enough pressure to cut through the film cleanly but not so much that the blade marks the surface beneath. It is important to use absolutely sharp, lightweight X-acto knife blades. Discard any that have become dulled; it is a false economy to try to get further use out of them, as this risks spoiling a piece of film or artboard and may waste previous careful work.

The other crucial element in using masking film is to apply it always to a surface that is clean and dry and to remove it as soon as it is no longer needed. Otherwise it may ruin the surface effect achieved in previous sprayings, or it will adhere imperfectly and allow color to bleed under the edges. Masking film left too long on the support may also deposit particles of adhesive, especially in a warm atmosphere, which will spoil the finished surface.

The process of cutting masking film needs a delicate touch, and there are two likely errors that can be made. One is to cut the mask too deeply **1**, causing score marks in the surface below which are visible when the spraying is complete. The color accumulates in the score mark, causing a dark, ragged line. If the film is not cut cleanly right through, however, it will tear unevenly from the partly-cut edge **2** when a section is lifted.

3

5

Masking film only functions efficiently if it is applied to a clean, dry surface, and although the adhesive is low-tack, if left on too long it can cause damage. When film is applied over color that is still wet **3**, it does not adhere firmly and smudges the surface of the sprayed area. Masking film left on the support too long may lift the color below **4** when it is removed, making a roughened and patchy texture.

Poor adhesion at the edge of a mask allows color to bleed and dry to a ragged edge underneath the film **5**. This may occur if the surface of the support is greasy or dusty and the adhesive fails to grip. Keeping the exposed surface clean before and after cutting a mask is important. Fingerprints left on the support show through the spraying **6** and are not easily disguised even if several layers of color are applied.

4

6

ERRORS AND PROBLEMS

CUTTING MASKING FILM:
ANGLES AND CURVES

Accuracy in cutting masking film to form angles, curves and intricate details comes only with practice. It is difficult to follow a line precisely when working freehand, even if you have a keen eye and a steady hand, so it is advisable to use a ruler or template to guide the blade. The techniques of cutting shown here demonstrate some basic principles that help to obtain good results, but every artist should be willing to devise his or her own methods that feel comfortable and solve particular problems in a piece of artwork. The correct technique is the one that works.

General rules are useful: placing the ruler or template on the outer side of the line while cutting so that it covers the edge of the mask that will stay in place; keeping the X-acto knife blade at right-angles to the surface to avoid undercutting the edge of the film and spoiling the line of the cut; working toward a previously cut edge to avoid lifting or tearing the masking film at the beginning of the cut. On occasions, however, the airbrusher needs to improvise a solution, as demonstrated on pages 22 and 23, which show how to cut parallel curves by taping two X-acto knives together.

1

2

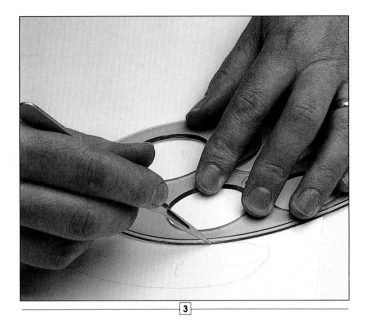

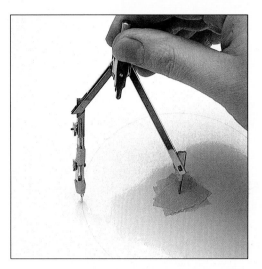

When cutting a straight line using a ruler as a guide, always position the ruler on the outer side of the line **1** so that it is resting on the edge of the mask that will stay in place when the cut section is lifted. This makes a clean cut, helps to anchor the mask, and enables you to see where you are cutting in relation to the whole outline of the shape. Angular shapes present particular problems in mask cutting. Start to cut at the point of the angle and continue on a smooth line outward **2**. When cutting the second line to make the angle, work toward the previous cut and make sure that the two cut lines connect precisely, otherwise the mask will tear unevenly at the point of the angle when lifted. Try to avoid cutting into the shape, as this makes it more difficult to replace the mask section cleanly after spraying. When cutting curves, where possible use a French curve **3** or ellipse template to guide the X-acto knife, as it is very difficult to cut a curve smoothly when working freehand. If using plastic templates, cut with the tip of the blade, using a light but firm touch. Be careful to avoid shaving the edge of the template, as with a clumsy movement it is possible to cut into the plastic which is relatively soft.

When cutting a circle using a blade attachment to a compass, it is necessary to protect the masking film from being pierced by the compass point. This can be done by placing a few layers of masking tape at the center of the circle to cushion the point.

There is a tendency to slight inaccuracy in the motion of most compasses, which may result in the returning blade being slightly out of line with the start of the cut. To avoid this, turn the compass with a slight stroking motion.

ANGLES AND CURVES

**CUTTING PARALLEL
LINES WITH A
DOUBLE X-ACTO KNIFE**

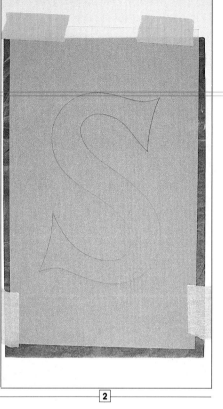

Cutting fine parallel lines is a difficult task if the lines are cut singly; whether working freehand or using a template, some inaccuracy generally occurs. The solution used here is to tape two X-acto knives together, making it possible to cut with both blades at the same time. Bind the knives securely with masking tape **1** at the top end of the handle and the neck; it may also be necessary to tape the blades, all but the cutting tips, as they are flexible and may bow outward under pressure. Transfer the drawing to the support **2** and cover the whole surface with masking film. Cut carefully around the outline with the taped knives; make sure that the tip of the outer blade does not lift on the curves. Remove the background masking and spray a graded tone of blue **3**.

When the color is dry, replace the masking film over the background area and lift the section of mask inside the shape of the "S", leaving in place the narrow band of masking film between the parallel cuts. Spray the central area of the "S" with a graded tone of green **4**. Allow this to dry completely before replacing the piece of masking film. Lift the narrow strip of film on the outline of the "S" and remove it. Spray the outline with yellow **5**. When all the masking film is removed, the result is a cleanly outlined shape with an even color border **6**. The technique of cutting with two X-acto knives requires some practice before you achieve a perfect result, but it is particularly useful for cutting parallel curves, for outlining and accurate masking of individual details.

MASKING SEQUENCES: OVERSPRAYING COLOR AND TONE

The masking methods devised to meet particular problems depend both upon the color effects required and the medium being used. Tonal gradations, for example, are applied directly in watercolor by overspraying of the color to build up the darker tones. When the medium is opaque, as with gouache, tonal gradations can either be mixed in the palette and separately sprayed, or a double-masking sequence can be applied.

It is a matter of the artist's choice whether a mask applied in two stages utilizes the same pieces of film or involves cutting a new mask. Sometimes it is preferred to complete all the cutting in the first stage and rely on accurate replacement of mask sections. A relevant factor is the build-up of spray on the mask, which eventually makes it difficult to see through to the previous spraying, in turn making it difficult to balance tones and colors. The first exercise shown here uses two pieces of masking film, one for the colors, a second for the tones: it can alternatively be carried out by cutting all the lines at the first stage, treating each color block and each plane as three mask sections.

Draw a large cube in perspective and line up the small inner cubes from the top front corner. Apply masking film evenly to the whole surface of the support. Cut the film along the outlines of each cube **1**. Use masking tape to hinge the smallest cube and peel back the section of masking film. Spray with yellow gouache **2**.

Replace the hinged mask section when the yellow paint has dried. Hinge the second section of the mask in the same way, lift and turn it back. Spray with red gouache, working over the masked yellow cube **3**. Replace the mask when the red is dry; lift the outer section of the mask and spray with blue gouache **4**.

Remove all the pieces of masking film within the outline of the cube. Make sure that the surface is dry and lay a clean piece of masking film over the cube, overlapping the background masking **5**. Cut along the lines describing the planes of the large cube. Turn back the left-hand section and spray lightly with black **6**.

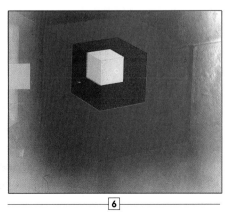

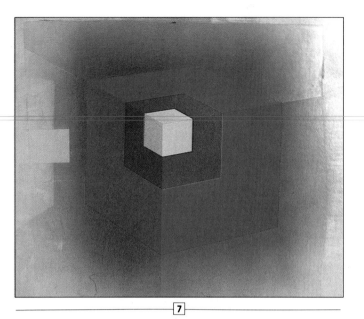

7

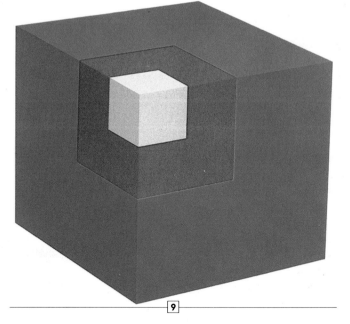

8

Remove the section of masking film covering the right-hand plane of the large cube. Again using black gouache, spray lightly across the area, judging the amount of color carefully to produce a tone slightly lighter than that applied to the left-hand side **7**. You should now begin to see the three-dimensional effect of the cube. Remove the final piece of mask from the top of the cube and spray a lightly graded tone across the back corner **8**, leaving the front corner unsprayed to show the original colors. When the spraying is completed and the color has dried, remove all the remaining masking film **9**. The effect is of a solid cube containing the variations of color.

9

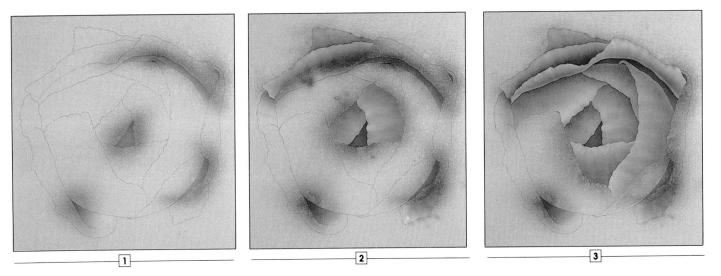

1 2 3

USING A TRANSPARENT MEDIUM

When spraying with watercolor, the masking sequence follows the pattern of the image, working from the darkest to the lightest areas in each stage. The cabbage is drawn in outline and the drawing completely covered with masking film. The areas of deep shadow **1** are first unmasked and sprayed in gray-blue. The drawings (above) show the sections of the mask lifted at each stage, starting with the leaves edged with shadow **2** which are sprayed with graded tone to produce the textured effect. As the mask sections are lifted the darker tone in any area is sprayed against a masked edge **3** until the image is complete **4**.

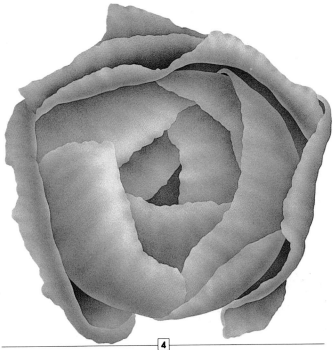

4

OVERSPRAYING COLOR AND TONE

PINK TILES DAVID HOLMES

This is an example of the precision of airbrushing using masking film to create clean lines between hard-edged shapes painted with a high contrast of color and tone. The three-dimensionality of the subject is effectively described by economical means.

ARCHES DAVID HOLMES

This airbrush painting is based on an illusionistic perspective design by M. C. Escher. A rounded knife blade was used to cut the masking film around the curved arches and the artist worked in gouache to build up the effect of thick pastel color.

PANTHER PETER KELLY

The fluid outline of the panther dominates a landscape sprayed with flat and graded colors. Masking film was used to define the color areas. The artist sprayed the solid black first and gradually removed the masking as the lighter colors were applied.

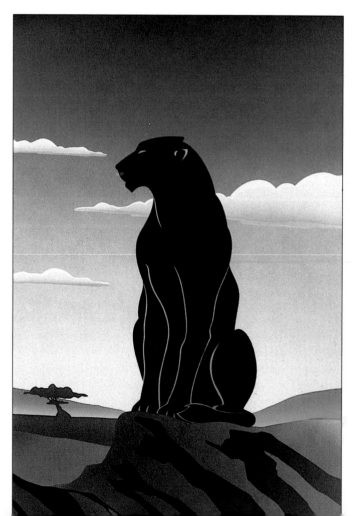

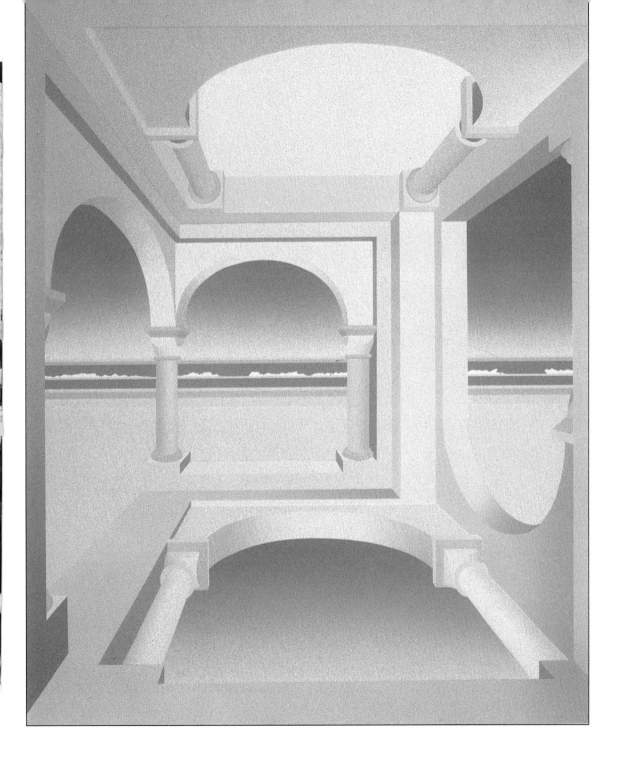

OVERSPRAYING COLOR AND TONE

USING PLASTIC TEMPLATES: REGULAR SHAPES AND CURVES

In graphic work there is often the need to include very precise shapes which it is difficult to draw by hand: the ellipse is a good example of forms of this type, a shape that is frequently required to represent a perspective disk, as in the cross-section of a cylinder or the rim or base of a rounded object. Preformed plastic templates provide various sizes of circles and ellipses (right). To deal with irregular curved lines and rounded or pointed curved shapes, there are several different types of templates known as French curves which present a combination of these elements. Set-squares are also useful equipment, providing guidelines for given angles.

Templates are used in airbrushing in two ways: for drawing up shapes to be cut when an image is masked with masking film, or for direct use as masks, spraying through or around the template shapes. When the template is used as the mask for spraying, the shape can be repeated very precisely, to give an impression of shadow or movement, for example. The only disadvantage is that the size of the circle, ellipse or curve is fixed. However, this can be taken into account when planning the scale of the work.

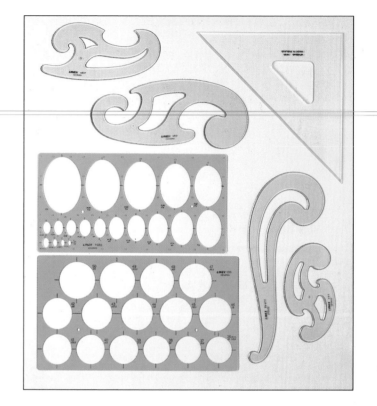

To airbrush an ellipse using a plastic template, first select the correct size of ellipse for the job in hand and position the template on the support. Cut a hole in a piece of tracing paper, large enough to surround the ellipse, and place the paper over the template centered on the shape to be airbrushed. Secure the edges firmly with masking tape. Spray into the ellipse **1**, being careful not to angle the spray across the edges of the template as this causes a buildup of color which can bleed underneath. The effect can be of flat color or graded tone **2**, depending on the effect that is required. Use a circle template in the same way **3**, masking off the unused part of the template with tracing paper to cover the surrounding shapes which are not being used. Apply graded tone to create the effect of a sphere **4**, or airbrush the circle with flat color, as required.

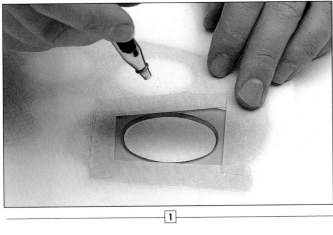

1

2

3

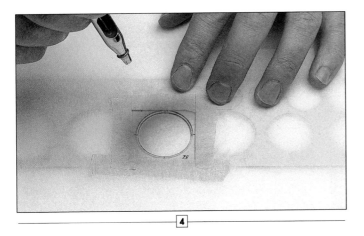

4

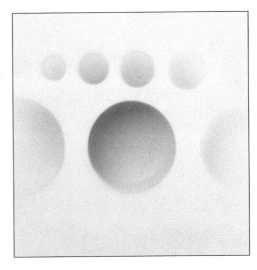

Templates are drawing·aids designed to include as many useful shapes as possible within the overall area, so the holes are closely spaced and vary in size. When templates are used for airbrushing, it is important to block out the shapes not being used, or the spray will drift into them causing unwanted areas of color on the support (above). These are naturally less distinct than the area directly airbrushed but an error of this kind can waste materials or spoil previous work.

1

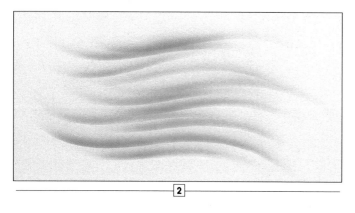

2

French curve templates can be used to repeat a single curve or build up a pattern of varied curves, by exploiting different edges and the interior shapes of the template. Use masking tape to block holes in the template and prevent the airbrush spray drifting onto other areas of the support. Spray close to the edge of the template to create a hard-edged effect **1**, but be careful not to allow an accumulation of wet color on the plastic which may penetrate beneath the edge of the template and seep onto the artwork. Clean the template as necessary when a line of spray is completed. In the finished example produced by this exercise **2**, the lines have been sprayed from different heights and the density of spray altered slightly to achieve variations in the quality of the curving lines.

The moving ball effect is an example of how a circle template can be used to create a particular visual sensation. Apply masking film to the support and use the template as a guide to cutting a circle. Airbrush the circle in solid color, lightening slightly toward the left-hand side **1**. Allow the color to dry and remove the mask **2**. Position the circle template a short distance from the airbrushed circle, with the right-hand edges aligned. Spray on the edge of the template to create a curve of graded tone. With the template removed **3**, this forms a shadow effect behind the original circle. Repeat the process to form a second curve of graded tone to the right of the first **4**. Continue in the same way, lightening the tone of the shadow curves **5** and increasing the space between them **6**.

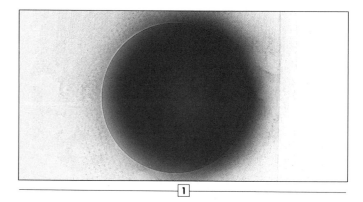

1

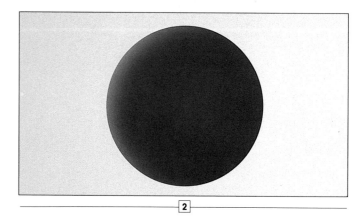

2

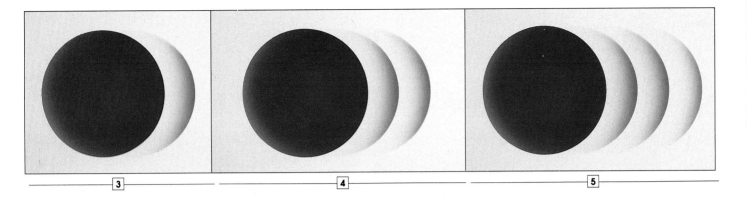

REGULAR SHAPES AND CURVES

CUT-CARDBOARD STENCILS: MOTIFS AND REPEAT PATTERNS

Stencils cut from cardboard are usable in similar ways to plastic templates, but the shape can also be designed in relation to the requirements of a particular piece of work to produce a single motif or a repeating pattern. This is an area of masking where the airbrush artist can invent a solution to a particular masking problem — to represent overlapping fish-scales, for example, or a starry sky — by cutting an individual shape that can be used in different ways. This may be more economical of effort in certain situations, saving time on cutting when repeating a shape using masking film would be a more elaborate process. The stencils can also be positioned at different heights to vary the edge qualities.

The material used to make a stencil depends upon the amount of wear it is required to withstand. Heavy cardboard is extremely durable; paper and thin cardboard may buckle if repeatedly wetted with the airbrush spray. Acetate is a useful material for fine work; it is resistant to the spray and can be cut very precisely. To keep the work clean, especially where more than one color is used, avoid a buildup of color at the stencil edges which may bleed underneath.

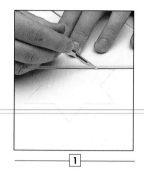

CUTTING A STENCIL FROM CARDBOARD

1

Draw up the shape of the stencil on thick cardboard; this example shows a six-pointed star. When cutting straight lines, use the straight edge of a set-square or a ruler to guide the X-acto knife **1**. Make sure all the lines are cut cleanly and pay special attention to cutting sharply into angles so that the shape lifts out cleanly **2**. When using the stencil, hold it flat on the support or slightly above **3**, depending upon the effect required. Variations of graded tone create solid, vignetted or patterned shapes **4**.

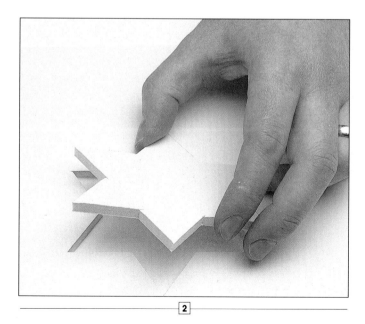

2

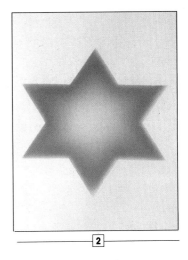

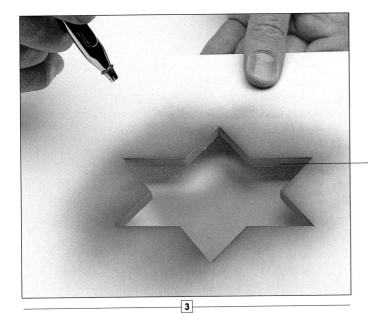

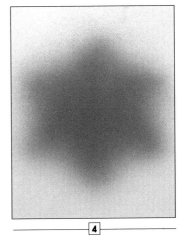

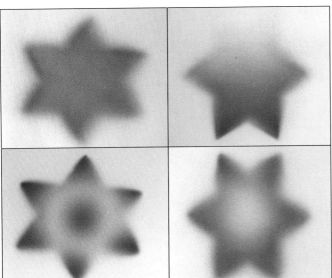

A HARD-EDGED IMAGE

To make a hard-edged image of the stenciled shape, hold the stencil flat on the support and spray with the airbrush perpendicular to the surface **1**. Graded tone is used here, faded into the center of the star **2**. Repeat the exercise holding the stencil about 5cm (2in) above the support, again keeping the airbrush upright above the spray area **3**. The result here is a very blurred, soft image barely defining the original shape **4**.

A SOFT-EDGED IMAGE

MOTIFS AND REPEAT PATTERNS

USING STENCILS:
MULTIPLE IMAGES

To use a single stencil to form a multiple image, cut the basic shape from cardboard and spray through it onto the support **1**. Move the stencil to the next position and spray again: repeat this to form the required effect **2**. When spraying in more than one color, make sure there is no buildup of the first color on the edges of the stencil before spraying the second **3**. Use a transparent medium to obtain the full effect of the overlapping shapes forming a third color area **4**.

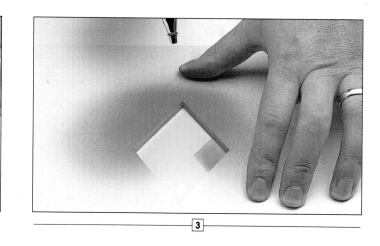

1

2

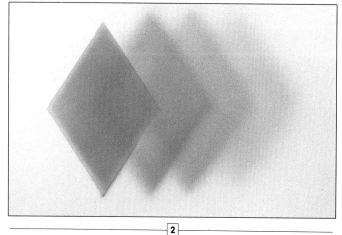

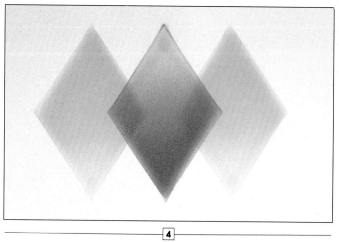

3

4

The same stencil can be used to make a varied range of shapes and patterns. Regular overlapping of the diamond stencil produces a complex star shape with dark tones where the points intersect. Different configurations produce the folded petal effect and diamond-centered star. The star-shaped stencil (see previous page) is used to demonstrate the effects of turning the stencil for the second spraying to produce a twelve-pointed star and repeating the shape in lighter tones to make receding shapes.

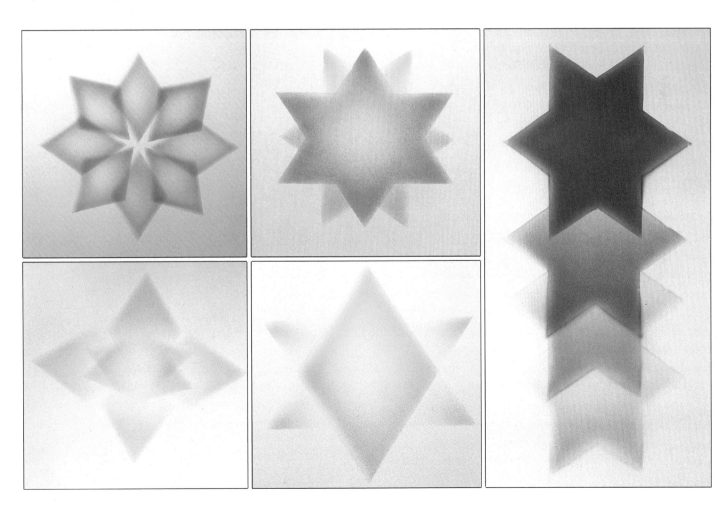

LOOSE MASKING:
CUT AND TORN CARDBOARD

A loose mask is one that does not adhere to the surface of the support. Paper, cardboard and acetate are the materials most commonly used: the mask may be cut to shape or, in the case of cardboard or paper, torn to create a rough edge. Loose masking is less precise than film masking, but it is a flexible method: the position of the mask can be changed if required, and the spray effect varies according to the distance of the mask from the support.

When a loose mask is held flat on the support, the airbrushing follows the line of the cut or torn edge quite precisely. The precision of the sprayed area decreases as the mask is moved away from the support. The higher the mask is held, the less well-defined is the area of spray, and some color begins to drift under the mask, further diffusing the effect. Loose masking effects are often used in artwork to contrast with the clean, hard edges made by masking film.

Different thicknesses of material produce slightly different edge qualities. This is an area worth experiment to see how the range of effects can be applied to an individual style in airbrushing.

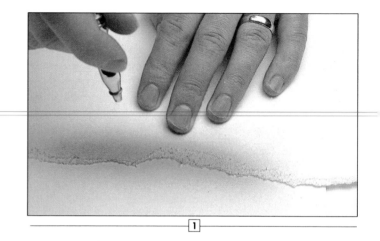

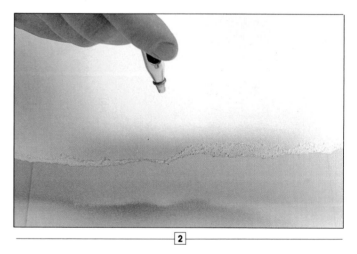

These exercises show the effect of using the same type of loose mask held on and above the support to create different results. A torn edge on a piece of thin cardboard **1**, when held flat against the support, creates a crisply ragged edge. When the torn edge is held 5-8cm (2-3in) above the support **2**, the outline of the airbrushed colour is softened and hazy. Loose masks of this type are useful for pictorial effects such as tree-lined horizons or clouds. The top two pictures (far right) show the finished samples.

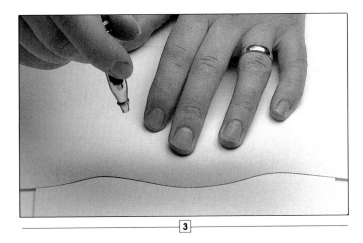

3

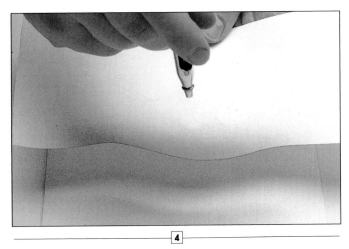

4

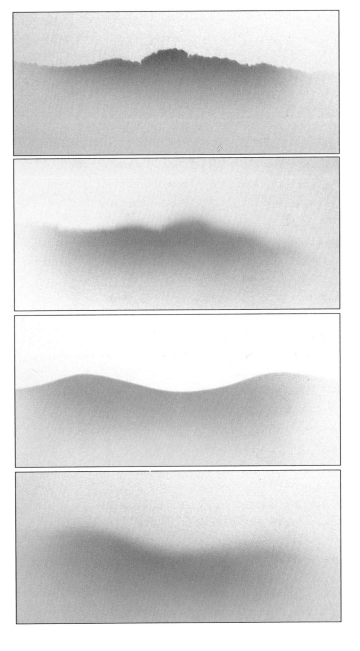

The same method using a loose paper mask with a cut edge produces cleanly defined curves when the mask is flat to the support **3**, but the definition is lost when the mask is held above the surface **4**, though the general shape of the curves is retained. The finished samples are shown in the lower pictures (far right). In each exercise the airbrush is held perpendicular to the mask. When reusing a loose mask, make sure the lower side is free of paint if the mask is designed to touch the support.

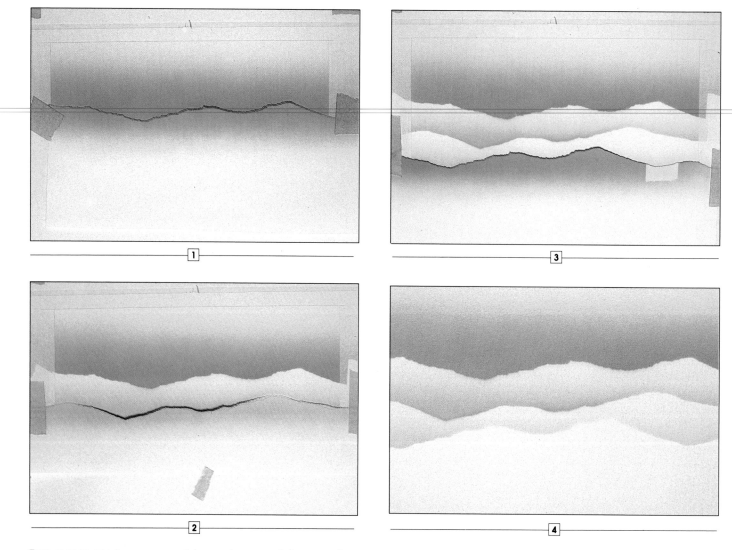

Torn paper masks are a useful way to suggest the receding impression of a distant, mountainous horizon. Mask the whole image area with film to define the edges of the artwork. Tear one side of a strip of paper and tape it in position to define the darkest area of the image. Spray a dark tone across the edge of the loose mask, fading toward the film-masked edge of the artwork. **1** Position a second mask above the color area and spray a slightly lighter graded tone **2**. Reuse the first mask, off-center from its previous position, to create a third layer of graded tone **3**. Spray very lightly across the remaining white area **4**.

Softly undulating wave effects are produced by using loose masks with cut curves, allowing the shapes to overlap and varying their height above the support. Both these examples combine hard and soft edges to produce an all-over pattern of waves **1** and a light-to-dark gradation **2**.

1

2

In an illustration involving a precise keyline drawing, photocopies of the original line drawing form useful loose masks that reproduce the detail of the image. At any stage of the work, the appropriate section of the image can be cut out to form a mask for a particular area, to work up shadow or highlight detail, for example. This is a useful alternative to film masking in some work as it provides more flexibility.

CUT AND TORN CARDBOARD

ZEBRAS JOHN ROGERS

This vivid illustration of zebras running was created with loose paper masks hand-held over the support to allow the airbrush spray to form contrasts of hard and soft edges across the pattern of black and white stripes.

YOU NEED HANDS PHIL DOBSON

The firm shapes in this design were mainly film-masked, but the range of texture and pattern shows the inventiveness sometimes needed in masking. In addition to acetate masks, the artist used such items as old socks and screwed-up paper to obtain the required effects.

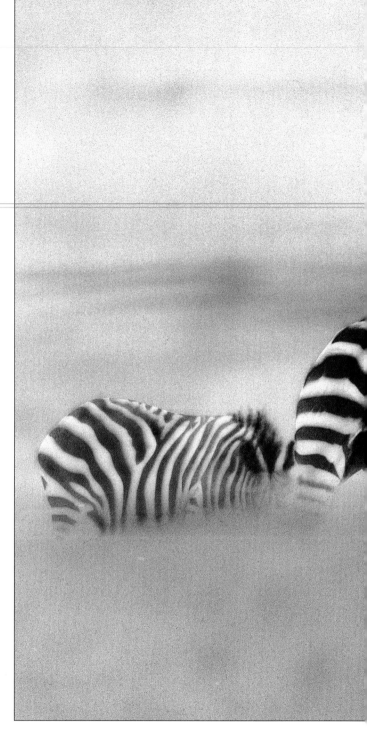

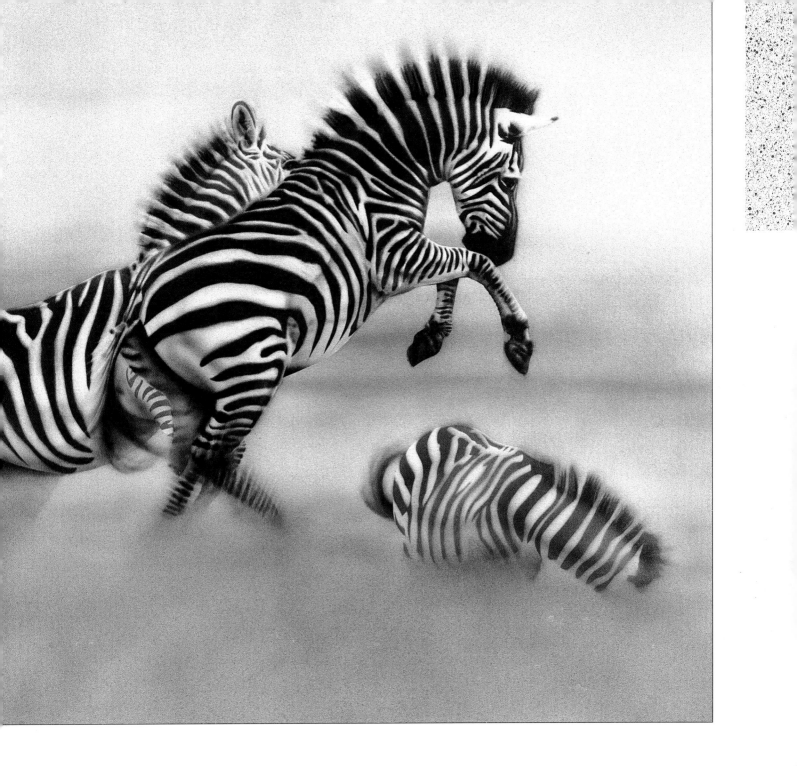

CUT AND TORN CARD

FINE DETAIL

MASKING FLUID: DETAIL AND TEXTURE

Masking fluid, also called liquid masking, is a rubber compound solution that is applied as a liquid and dries to a rubbery, non-porous skin. One use is for masking very fine details, such as lines that need to be drawn with a ruling pen or fine brush, or for small irregularly-edged areas that would be difficult to cut in masking film. The other valuable effect of masking fluid is to create areas of texture that can be given a random or complex finish, depending upon how the masking fluid is applied.

Once dry, the rubber compound can be removed by scraping with an X-acto knife, by lifting the edge and peeling it back with your fingers, or rubbing with a soft eraser. Allow the sprayed color to dry before removing the masking, to avoid smudging. It is advisable to test a masking fluid before using it in a major piece of artwork; some types leave a slight stain on the support and you should make sure the dried masking lifts easily without surface damage.

Masking fluid can be applied very finely and precisely with a ruling pen. Use a brush to load the fluid into the tip of the ruling pen **1**. Draw fine lines on the support with the pen; apply the masking fluid quickly and carefully, and do not allow it to dry inside the pen tip. Allow the lines of masking fluid to dry completely before spraying with color **2**. When the color is dry, use the tip of an X-acto knife blade to lift the rubbery skin of dried masking fluid cleanly from the support **3**.

COARSE DETAIL

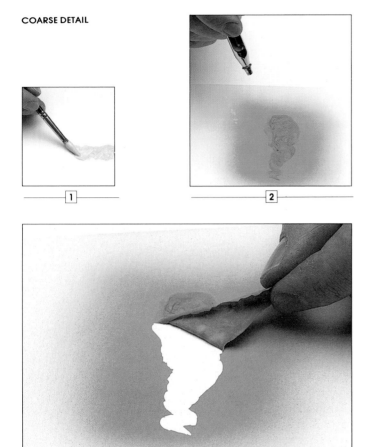

Use a brush to apply masking fluid directly to the support. Paint it on thickly **1** to mask the area completely; irregularities in the thickness of the fluid do not matter as long as it seals off the surface of the support. Allow the fluid to dry and spray color over and around the masked area **2**. When the color is dry, lift one end of the patch of rubbery masking with the blade of an X-acto knife and take it between finger and thumb; pull it gently away from the support, leaving a clean-edged area **3**.

Masking fluid dries quickly and can cause clogging of the paintbrush, which destroys the texture of the bristles and makes the rubber compound difficult to remove. The brush is more easily cleaned if covered with soap before the masking fluid is used: work up a lather on the brush using an ordinary bar of soap and clean water, then squeeze out the excess soap and work the brush bristles between your fingers to return them to shape.

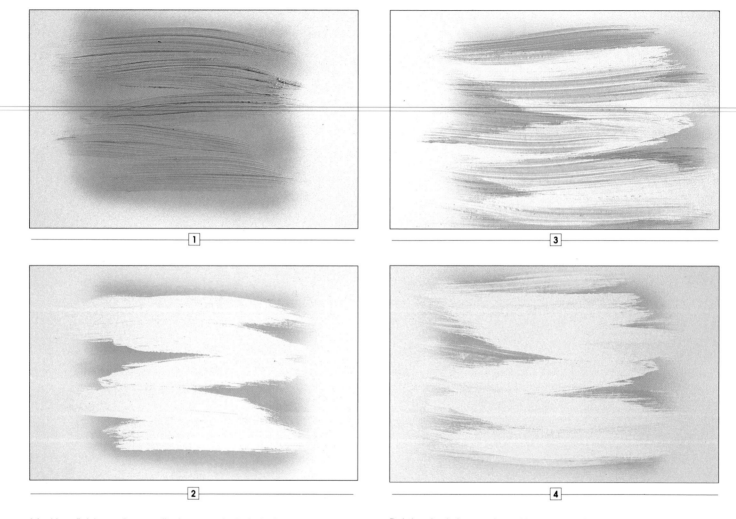

1	**3**
2	**4**

Masking fluid can be applied successively to build up a textured area in two or more colors. Apply the fluid loosely with a brush and leave it to dry. Spray over the whole area with the first color **1**. When this is dry, peel away the rubbery mask **2**; make sure there are no particles of dried fluid left on the support. Plan the areas of the image where the second color is to be applied according to the effect of the first color.

Paint a fresh layer of masking fluid over the areas of first color; if working in a transparent medium, note that where the first color is not masked, overspraying of the second color will create a third. When the masking fluid has dried, spray the second color **3**. Remove the rubbery mask once again to reveal the effect of the two colors **4**. You can continue this process to produce a more densely layered effect in several colors.

Monochromatic effects can also be given richness and depth by repeated layering of textured spraying. Apply masking fluid generously in the first instance, and spray the color lightly to obtain a mid-tone **1**. Remove the masking and reapply fluid, covering the area with a more broken texture. Spray again with a similar mid-tone **2**. When the masking is removed, the overlapped areas of spray automatically create a darker tone.

1

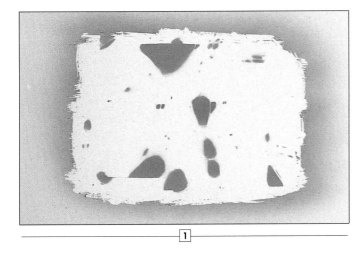

1

2

2

The previous example showed a randomly applied texture. In this exercise, the effect is more regulated in the way the masking fluid is applied. The first spraying **1** has a pattern created by applying the masking fluid with rough, evenly weighted brushstrokes. In second and third sprayings, the brushmarks are deliberately overlapped, creating an interesting patchworked pattern of solid and broken color areas **2**.

USING FABRICS TO CREATE SPRAYED TEXTURES

The many different types of fabric weave offer intriguing possibilities for masking, providing a means of creating regular or random patterns and textures depending upon the quality of the material. Fabric allows the airbrush artist greater variation of surface texture and can be used in combination with other masking techniques to introduce visual detail over large or small areas.

Openwork fabrics such as canvas and net provide the widest range of texture. The more open the weave, the more color penetrates the fabric mask: close weaves break up the color, giving a less predictable result. To avoid blurring the textured effect, the spraying should be built up in layers, but without allowing wet color to seep through the fibers onto the support. Provided the fabric is firmly taped to the surface, it should create a distinct "negative" effect of its own texture. If it lifts under the spray, the pattern is softened by drifting color.

Masking tape is adequate for securing a large piece of fabric, and it can be used to define the edges of the textured area. Alternatively, the fabric mask can be laid over film masking to confine the effect more precisely.

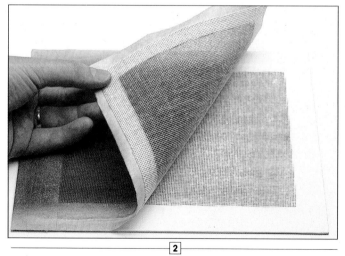

1

2

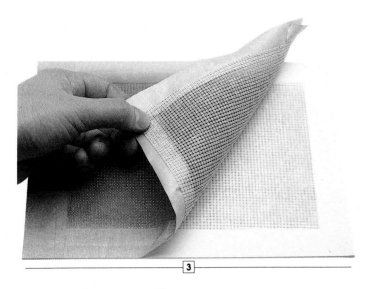

3

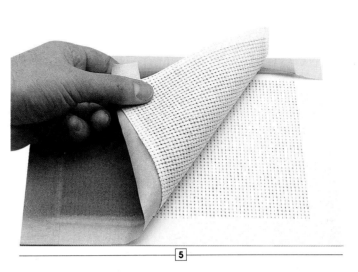

5

A grainy all-over texture **1** is obtained by spraying through a fine-weave embroidery fabric **2**. As with all these examples, masking tape is used both to hold the fabric in place and to create a clean-edged border around the spraying area. Spraying through the even weaves of tapestry **3** and embroidery canvas **4** creates a distinct, regular patterning in contrast with the texture made by a loose cotton scrim **5**, where the irregular warp and weft produce a more random result in the distribution of airbrushed color. Airbrush spraying transforms the holes of a rug canvas **6** into bold checks. Do not allow fabrics to become saturated with wet color, because this will bleed onto the support and destroy the pattern effect.

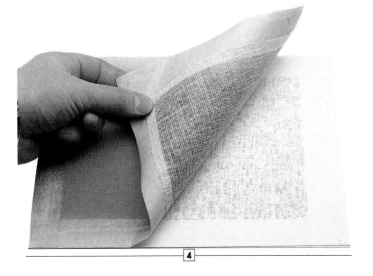

4

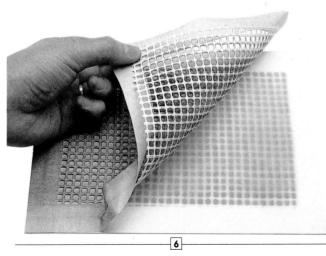

6

FOUND OBJECTS: THREE-DIMENSIONAL MASKING

The term "found object" is used to denote objects used in a creative context that are not normally associated with finished artwork or art materials. A three-dimensional object acts as a mask for airbrushing just as effectively as a piece of film, paper or cardboard, but because of its intrinsic shape, the effect of the image is less predictable. The only way, therefore, to discover which objects may form useful masks in your work is to experiment in the same way as the exercises shown on these pages.

Because a hard edge is achieved only through using a mask lying flush to the support, few found objects will supply a distinct hard-edged outline, as part or all of their shape will be raised slightly from the surface. This is equally true of the natural and man-made examples shown here, all of which tend to produce a softened texture or pattern. These effects can, like the fabric textures shown on the previous pages, be used in association with masking film or loose masking to vary the surface detail in an image.

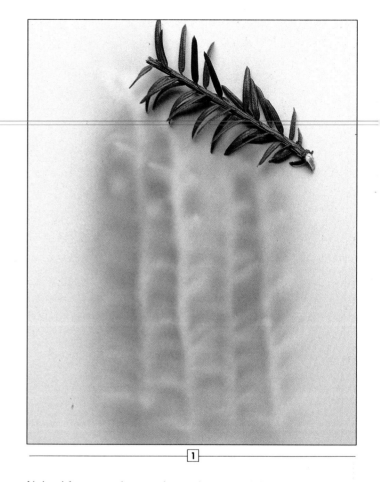

1

Natural forms used as masks produce a variety of textures, some having a random effect while others create distinctive patterns. A finely divided evergreen leaf **1** makes a ribbed herringbone effect; the leaf is repositioned carefully and resprayed to form a block repeat pattern. A pine-cone **2** produces a strangely cloudy, amorphous impression, whereas the clear-cut shape of an ivy leaf **3** provides a relatively sharp outline; in this example the leaf has been overlaid several times on the support to create a layered result. Spraying across a crumpled paper towel **4** forms an interesting pattern of soft curves and angles.

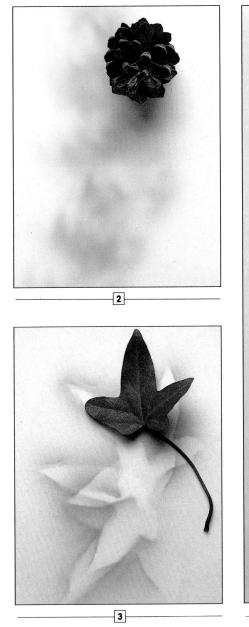

2

3

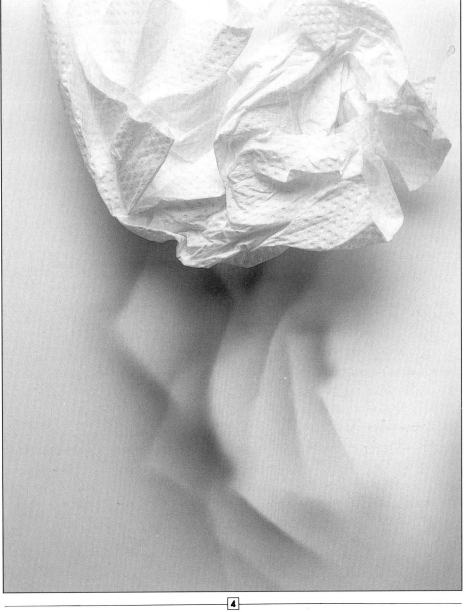

4

THREE-DIMENSIONAL MASKING

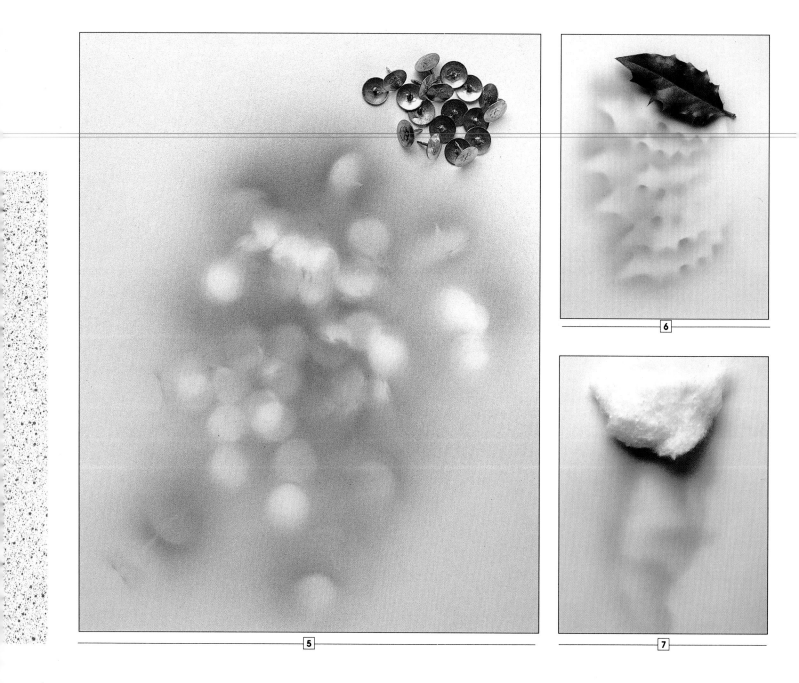

5

6

7

Everyday objects close to hand are useful material for found-object masking, such as a handful of thumbtacks **5** which forms a mass of tiny floating disks when sprayed. A holly leaf **6** provides a ragged-edged pattern that could be used as surface texture or shadow detail. Cotton **7** is the material often favored for airbrushing clouds; it provides an effect of soft mass, the two-dimensional equivalent of its actual texture. This can be used as a positive mask, as here, to leave white areas, or as a negative mask for spraying opaque white. A gnarled twig **8** produces a loosely defined splash-like pattern.

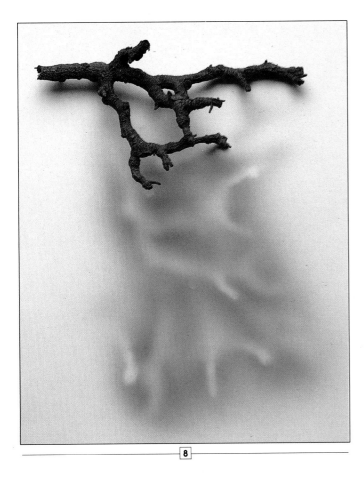

8

Found objects will often be used in repeated sprayings, and there is a danger that the object forming the mask becomes wetted out by the airbrush spray, causing color to seep onto the surface of the support if the material is not absorbent, or to soak through porous materials causing a color stain below. With a leaf pattern or other distinctive shape, allow the color to dry or blot off the object between sprayings.

THREE-DIMENSIONAL MASKING

PROJECT: COMBINED
MASKING TECHNIQUES

Many styles of airbrush artwork involve the use of more than one type of masking to cover the range of visual effects required in the completed image. This landscape has been devised to include the techniques of applying masking film, loose masks, masking fluid and stencils to demonstrate the combination of these elements. The quality of the airbrush spray provides a unified surface finish that blends the separate sections of the image into a cohesive whole.

The project also combines the use of transparent watercolor and opaque gouache to vary the effects of color and texture. The clouds, for example, are sprayed over cotton masking after the initial color is applied, so white gouache is used to overlay white on blue. In the distant and middleground of the picture, watercolor provides the subtlety and luminosity of the graded tones; the sequence of spraying here works from dark to light in each area. To give the stone wall an overall warm tone, transparent color is sprayed over the shadow areas and textured spray already applied. In the foreground, gouache is again used to build up the heavy texture of the grass.

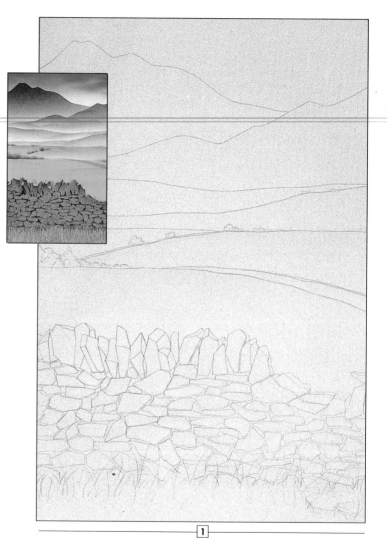

1

A precise keyline drawing is needed as a guideline to the different areas of masking. Draw up the image on tracing paper **1**, either directly or by tracing from an original on paper. Keep in mind the effects of color and texture required for the finished image (inset) when planning the masking sequence.

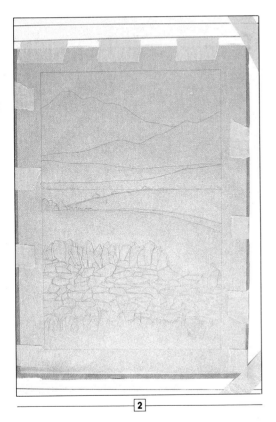

2

3

4

Use graphite paper to transfer the drawing to the surface of the support **2**. It is necessary to include the line detail of the stone wall (see page 59), but other areas need only be outlined since the texture and detail will be applied using loose masks and stencils. When a clean image is obtained, cover the upper section of the drawing with masking film. Cut and lift the section of mask on the area of sky and apply a graded tone of blue using watercolor **3**. Build up the color to achieve a stronger tone toward the top edge of the image. Clean out the airbrush and charge it with opaque white gouache: using cotton masking, apply soft-edged areas of white to create the effect of clouds **4**. If necessary, rework the sky with blue gouache to alter the cloud shapes, then soften the effect by respraying with white.

COMBINED MASKING TECHNIQUES

Continue to work the grassed areas in graded tones of green, working from dark to light in each section. Leave in place the piece of film masking covering the line of the road on the right-hand side of the drawing while spraying the area above **6**. Remove the section of mask directly above and spray with blue-green, again working from dark to light **7**. The addition of blue helps to increase the sense of distance and forms a color link between middleground and far horizon.

6

7

Apply masking film to the artboard, allowing a border around the drawing. Cut the film to expose the shapes of the grassy areas above and below the wall. Spray the foreground with green watercolor to form the base for stencil work (see page 60). Spray graded tone horizontally across the central area of the image **5**.

5

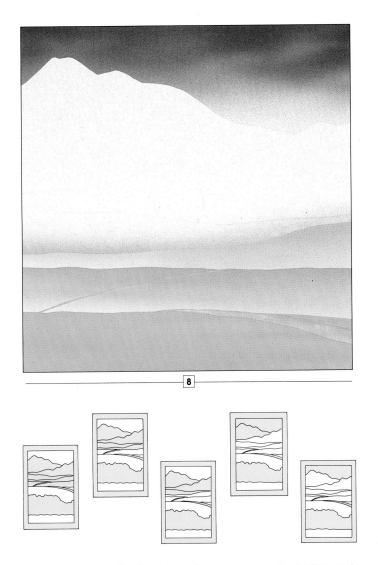

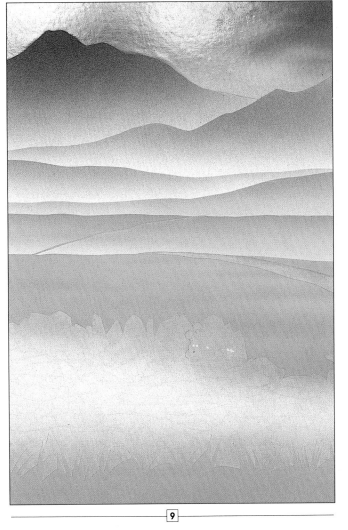

Cut the film along the line above the previous masked edge and lift the mask section. Mix the blue-green previously used with a little Payne's gray to spray the graded tone, then increase the gray content when mixing the color to spray the hill rising above **8**, so the effect is of a subtly changing color sequence.

Cut and unmask the area that forms the far horizon. Use pure Payne's gray to spray this section **9**, applying a graded tone darkening at the top edge to stand out against the sky. There is no need to replace mask sections during this sequence, since each area is worked dark to light toward the previously sprayed edge.

COMBINED MASKING TECHNIQUES

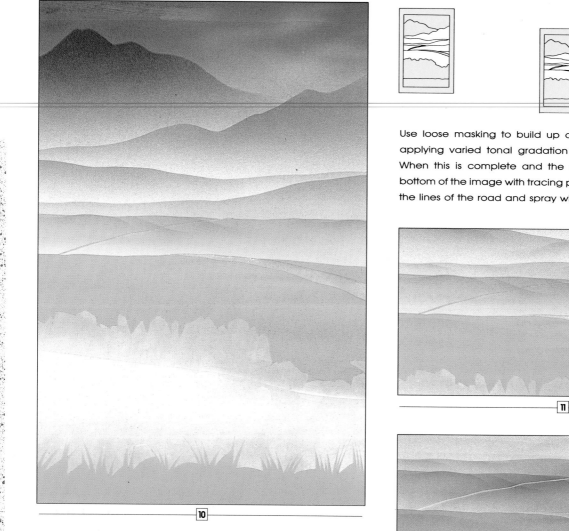

Use loose masking to build up detail in the shapes of the hills, applying varied tonal gradation to create a rippling effect **11**. When this is complete and the color dry, protect the top and bottom of the image with tracing paper taped in place; then mask the lines of the road and spray with yellow ocher **12**.

11

12

10

Replace sections of the mask to leave only the central band of green exposed. Work freehand to add tonal detail and suggest undulations in the surface of the grass **10**. Maintain the light and dark areas as in the original tonal gradation, but cross this with lines of shadow smoothly graded onto the underlying color.

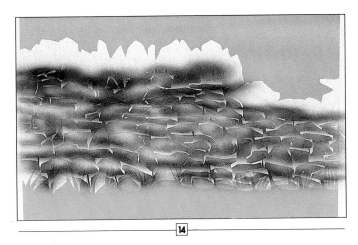

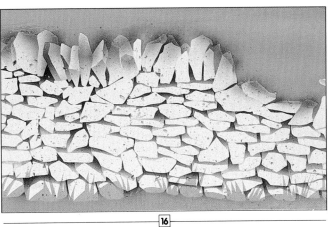

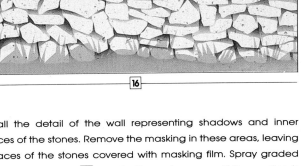

Cut all the detail of the wall representing shadows and inner surfaces of the stones. Remove the masking in these areas, leaving the faces of the stones covered with masking film. Spray graded tones of gray-brown **13**, gradually moving up until the section is completed **14**. Remove the masking on the lower part of the wall and spray shadow detail in the top edge **15**. Keeping the outer masks in place, apply masking fluid to the wall as a mottled texture by flicking it from the bristles of a toothbrush **16**.

COMBINED MASKING TECHNIQUES

Spray the wall with a spattered texture in dark gray-brown **17**, using a spatter cap attachment or varying the paint/air ratio with the airbrush control button. Remove remaining mask sections from the top of the wall and lift the dried masking fluid. Spray the whole area with a light tone of yellow-brown **18**. Remove the masking from the foreground and use a cardboard stencil to apply yellow-green grass blades **19**. Work freehand or with templates to develop the detail of grass and flowers in gouache **20**.

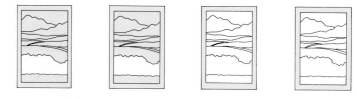

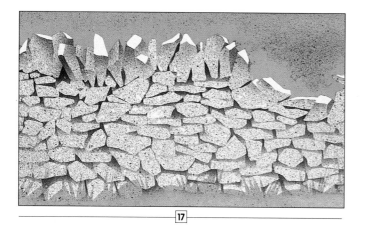

18

19

17

20

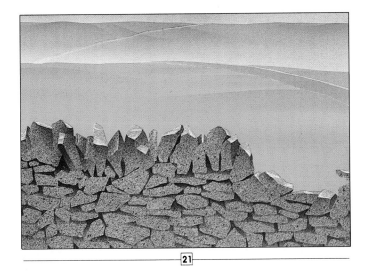

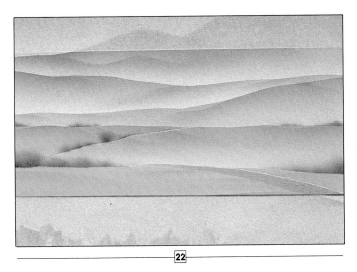

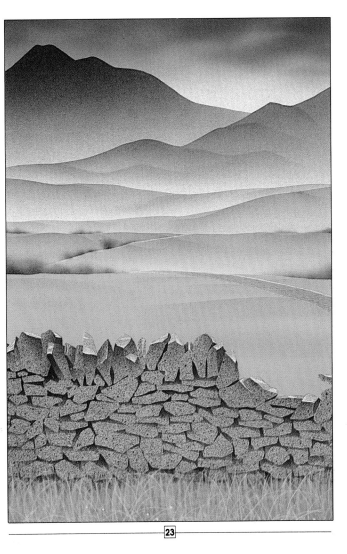

To complete the textured effect of the wall, lightly scrape the faces of the upper stones with an X-acto knife to scratch back the color, creating highlight areas **21**. Use loose masks and stencils to spray the rough shapes of bushes and trees in the middleground of the landscape **22**, using dark green gouache.

The finished picture **23** demonstrates the contrast of the clean edges of areas masked with film against the softened effect of loose cardboard masks and cotton. The textural detail and strong coloring in the foreground stands out against the subtly graded tones describing the more distant landscape.

COMBINED MASKING TECHNIQUES

GLOSSARY

Acetate A transparent film, produced in a variety of weights and thicknesses, used in airbrush work for loose masking and cut stencils.

Artboard A smooth-surfaced support particularly suitable for airbrushing since the surface allows a high degree of finish to graphic work and illustration. It is available in various thicknesses, flexible or rigid.

Artwork A graphic image or illustration of any kind, which may be intended for reproduction.

Bleed 1 A ragged line of color caused by paint penetrating beneath the edge of a mask. **2** The effect of a color which shows through an overlying layer of opaque paint: this occurs naturally with certain strong pigments and the label of a paint with this characteristic may carry a warning of the tendency to bleed.

Color cup A type of paint reservoir attached to certain types of airbrush; a metal bowl which is an integral part of the tool.

Compressor An electrically-driven mechanism designed to supply a continuous source of air to an airbrush.

Double-action The mechanism of an airbrush which allows paint and air supplies to be separately manipulated by the airbrush user. In independent double-action airbrushes, paint and air can be fed through in variable proportions, enabling the user to adjust the spray quality.

Film masking *See* Masking film.

Found object An everyday object or natural form which may be used as a mask, i.e. placed in the path of the airbrush spray to form an irregular outline, pattern or texture.

Freehand The technique of airbrushing without use of masks.

French curve A preformed template consisting of a combination of irregular curves and curved shapes.

Gouache A type of paint consisting of pigment in a gum binder and including a filler substance that makes the color opaque. It is a viscous substance and must be diluted with water to a fluid consistency for use in airbrushing.

Grain The surface quality of paper or board resulting from the texture of its constituent fibers and the degree of surface finish.

Graphite paper A transfer paper coated with graphite on one side.

Hard edge The boundary of a shape or area of color in an airbrush image which forms a clean edge between that and the adjacent section of the image. In airbrushing, this effect is produced by hard masking.

Hard masking The use of masks such as masking film or stiff cardboard which lie flush with the surface of the support and create sharp outlines to the masked shapes.

Highlights The lightest areas of an image.

Illustration An image accompanying a specific text or depicting a given idea or action; often intended for reproduction in printed works.

Ink A liquid medium for drawing and painting, available in black, white and a range of colors; ink is categorized as a transparent medium.

Internal atomization The process by which medium and air supply are brought together within the nozzle of an airbrush to produce the fine atomized spray of color.

Keyline An outline drawing establishing the area of an image and the structure of its component parts.

Loose masking The use of materials such as paper, cardboard, plastic templates, fabrics etc., as masks for airbrush work, which do not adhere to the surface of the support and can be lifted or repositioned according to the effect required. *See* Found object.

Mask Any material or object placed in the path of the airbrush spray to prevent the spray from falling onto the surface of the support. *See* Hard masking, Loose masking, Masking film, Masking fluid, Soft masking.

Masking film A flexible, self-adhesive transparent plastic film laid over a sup-

port to act as a mask. The material adheres to the surface of the support, but the quality of the adhesive allows it to be lifted cleanly without damage to the underlying surface. This is the most precise masking material for airbrush work.

Masking fluid A rubber compound solution that can be applied to a support with a brush or ruling pen and dries to a soft rubbery skin that is easily peeled off or removed with an X-acto knife or eraser. It is used in airbrushing for masking small details and irregular textures.

Medium The substance used for creating or coloring an image, e.g. paint or ink. *See* Gouache, Ink, Watercolor.

Needle A component of the airbrush which has the function of carrying the medium from the paint reservoir to the nozzle of the airbrush.

Opaque medium A paint capable of concealing surface marks, such as lines of a drawing or previous layers of paint. This is due to a filler in the paint which makes it tend to dry to a flat, even finish of solid color. *See* Gouache.

Propellant The mechanism used to supply air to an airbrush. Cans of compressed air are available which can be attached to the airbrush by a valve and airhose, but a compressor is the most efficient means of continuous supply.

Pulsing An action produced by certain types of compressor which cannot store air and may provide a slightly uneven air supply which affects the quality of the airbrush spray.

Rendering The process of developing a composition from a simple drawing to a highly finished, often illusionistic image.

Reservoir The part of an airbrush which contains the supply of medium to be converted into spray form. In some airbrushes this is a recess in the body of the airbrush or a jar attached above or below the paint channel.

Scratching back The process of scraping paint from a support with an X-acto knife or other fine blade to create a highlight area or remove color when an error has been made.

Soft edge The effect of using loose masks or freehand airbrushing to create indefinite outlines and soften the transition between one area of an image and the next.

Soft masking The use of masks held at a distance from the support surface to soften the sprayed area, or a masking material which creates an amorphous effect, such as cotton.

Stencil A sheet material such as cardboard, acetate or waxed paper, bearing the cutout shape of a motif or image. Color is applied through the cutout to reproduce the shape on an underlying surface.

Template A preformed shape used as a drawing aid or as a mask for airbrushing.

Tone 1 The scale of relative values from light to dark, visually demonstrated in terms of the range from black, through gray, to white, but also applicable to color effects. **2** Any given value of lightness or darkness within a picture or design, or in an individual component of an image.

Transfer paper A fine paper coated on one side with graphite or compressed powder color, which is inserted underneath tracing paper and when traced over, transfers the image to the surface below.

Transparent medium A medium such as watercolor or ink which gains color intensity in successive applications but does not conceal underlying marks on the surface of the support.

Vignette 1 A graded tone. **2** An area of graded tone used to frame or focus a central image.

Watercolor A water-soluble paint consisting of finely ground pigment evenly dispersed in a gum binder. It is available in solid and liquid forms; liquid watercolor is the most useful type for airbrushing.

INDEX

acetate sheets
see loose making

angles, how to cut 20
Arches (David Holmes) 28

bleeds 19

circles, how to cut 21, 30, 32
cloud effects 38, 53, 54, 55
compass knives 8, 14, 21
curves, how to cut 20, 21, 30, 32

Dobson, Phil 42

ellipses, how to cut 30
Escher, M.C. 28

fabrics, creating textures with 48-9
found objects, as masks 42, 50-53
French curves 14, 21, 30, 32

gouache, grading tone with 24-6 28, 54-61
graphite paper 10-12

hard-edged shapes 28, 32, 35, 50
Holmes, David 28

Kelly, Peter 28
keyline drawings 41

liquid masking
see masking fluid

loose masking 7, 8, 38-42, 50, 54, 58
masking film
adhesion of 9, 18, 19; advantages and disadvantages of 7; cutting 18, 20-23; described 8; economy in using 15; hinging 14; problems in using 18; project in use of 54-61; tracing onto 12, 13; and two-color images 14-17
masking fluid 8, 44-7, 54, 59, 60
masking tape 8, 48, 49
multiple images 34, 36-7, 50

opaque media
see gouache
overspraying
and color and tone gradation 24-9, 46; and watercolors 7, 24

Panther (Peter Kelly) 28
parallel lines, how to cut 22
Pink Tiles (David Holmes) 28

Rogers, John 42
rulers, how to use 20, 21

spatter caps 60
stencils
from acetate 34; from cardboard 36-7; from paper 34; how to cut 34; how to use 35, 57, 60; and multiple images 36
supports, tracing onto 10-11
swivel knives 8

templates, plastic 21, 30-33
textures
created with fabrics 48-9; with masking fluid 44, 46-7
three-dimensional masks 42, 50-53
tracing paper 10-13
transfer paper 10
transparent media
see watercolor

watercolor
and overspraying 7, 24, 27, 46, 54, 55, 56; and show-through of keylines 10

X-acto knives
choice of 8; doubled 22-3; use of 20

You Need Hands (Phil Dobson) 42

Zebras (John Rogers) 42

CREDITS

pp28-29 David Holmes and Peter Kelly, courtesy of Meiklejohn illustration;
pp42-43 John Rogers, courtesy of Ian Fleming and Associates, and Phil Dobson

Demonstrations by Mark Taylor
Diagrams by Craig Austen